Olaf Metzel
Gerd Rohling
Ina Barfuss
Thomas Wachweger

B

e r

l i n

Festival of German Arts,
London 1987

ICA

Preface

4 To coincide with this year's Festival of German Arts on the occasion of the 750th anniversary of Berlin, the ICA is delighted to introduce the work of four contemporary Berlin artists.

The exhibition provides a timely update on a cultural arena which the ICA reviewed nine years ago with the exhibition *Berlin, a Critical View – Ugly Realism*. This survey show brought together over twenty artists, defining a specific impulse underlying art production in Berlin over half a century.

The current exhibition focuses however on just four artists, whose work represents an altogether heterogenous practice, yet who are bound by a single and unique socio-cultural context; despite international recognition, it is the first time that the sculptures and paintings of **Olaf Metzel, Gerd Rohling, Ina Barfuss** and **Thomas Wachweger** can be seen in Britain.

Berlin has become an emblem for a national history, both past and present. Within its own microcosm it represents the division of the whole country. Berlin has been a catalyst for political upheaval, a flash-point for student revolts and mass demonstrations. In the eyes of Europe, and of Germans in particular, it has acquired a unique status: it is at once the focus for division between East and West whilst simultaneously offering the potential for reconciliation.

Postwar developments have seen these divisions and contradictions, thrown together within the confines of a thriving but isolated city, reflected in the West Berlin art scene – always highly ideosyncratic and distinct from that of other centres of contemporary art, such as Cologne and Hamburg. Its artistic landscape is above all characterised by an instinctive affinity for destruction, decay and darkness, as well as a seismographical sensitivity to political and social unease.

It was here that seminal movements such as *Critical Realism* in the 70s and *Wild Painting* in the early 80s were born, and it seems impossible to imagine their arising out of a different urban context.

The artists in this exhibition were never part of any of the familiar, much publicised and catchily labelled movements within recent German art. Preferring the independence of the outsider, they have absorbed a myriad conflicting impulses which form and stimulate both painting and sculpture, creating a diversity that echoes the particular climate and style of the city from which they have emerged.

Anarchic, aggressive, shot through with flashes of irony and humour, their work foregrounds content rather than the mere painterly gesture, matter rather than manner. The result often culminates in a cutting critique of Germany's political heritage. A strong narrative undercurrent combines both painting and sculpture – conceptual art was never a forte of Berlin. Paradoxically sometimes, the tender and delicate handling of the medium belies the content, which can be sharply, indeed shockingly belligerent, voicing anger and dissent in bold and radical language.

For these reasons, the four artists brought together in this exhibition could be said to characterise a trend towards individual practice following a phase of collective movements, and, in terms of content, a move away from the mere body or autobiographical experience towards broader environmental, cultural and humanitarian concerns. This is not comfortable art; it confronts with the contentious, it challenges debate.

We would like to thank the artists for their commitment to the exhibition, and Wolfgang Max Faust for his contribution to the catalogue.

6 The exhibition was selected over three visits to Berlin in 1986. We are grateful to the British Council, Anselm Dreher, Wolfgang Max Faust, Christos Joachimides, Thomas Kempas, Sarah Kent, Ursula Prinz, Ingrid Raab, Britta Schmitz, Klaus Sonne, Karin Thomas, Gerald Winckler, Karstl Zellermeyer, and especially Clemens Fahnemann for their invaluable help and advice.

For lending works to the exhibition thanks are due to Galerie Silvio Baviera, Zurich; Berlinische Galerie, Berlin; Galerie Fahnemann, Berlin; Galerie Springer, Berlin; Galerie Munro, Hamburg; Galerie Sprüth, Cologne; also to Bazon Brock, Wolfgang Max Faust and Lello Papagna.

Without the generous financial support of the Berlin Senate and Mercedes-Benz this exhibition would not have been possible, and we would like to give special thanks to Jörg-Ingo Weber of the Berlin Senate for his enthusiasm for this project from its inception.

Andrea Schlieker
Curator

Vanishing points and sight lines:
Art from Berlin

The work of:
Olaf Metzel
Gerd Rohling
Ina Barfuss
Thomas Wachweger

Wolfgang Max Faust

Art from Berlin is above all an art of contradiction. In this, it is like the art of every western metropolis. For today society has dissolved into individual fragments, which, mainly separate, exist alongside each other. Culture no longer exists within a unified framework, either of class, as represented in earlier times by bourgeois society; or through homogenous concepts of art – like the traditional avant-garde movements – in which art can be channelled and concentrated. The juxtaposition and opposition of different artistic positions has therefore become the condition of the production of art. Although painting has developed in the West as a central area of discussion about art since the end of the seventies, it must be seen that even this has only happened in the form of a patchwork of different possibilities. Berlin played an important role in this patchwork. The *Wild Painting* of Rainer Fetting, Salome, Helmut Middendorf and Bernd Zimmer, and the works of their precursors Karl Horst Hoedicke, Bernd Koberling and Georg Baselitz showed echoes above all of expressionist tradition. It is clear that this is now only one of numerous possibilities for art.

More complex artistic concepts, characterised both by contact with different media and a changed notion of what constitutes an image are gaining prominence alongside the relatively uniform neo-expressionist attitude. It is this impulse that informs the work of **Metzel**, **Rohling**, **Barfuss** and **Wachweger**. Their works occupy different perspectives in the current art output of Berlin. They demonstrate that art today embodies a spectrum of concerns which address the most varied of relationships – politics, history, ethnology, everyday life, religion. The complexity of concerns, contradictions and interactions are inextricably linked with the central paradox of the city from which they have emerged – West Berlin.

This West German enclave in the German Democratic Republic, can only be reached along

8 transit routes and air corridors. Surrounded by a
110 km long wall, this incomplete city possesses the
most secure frontier in the world. Here, the Wall, the
reality and symbol of a divided Germany, has
become part of everyday life. Its Western side is
embellished with brashly-coloured graffiti, the East
with the death strip, barbed wire and watch towers.
In West Berlin people live with the schizophrenia of a
divided world almost as a fact of life. Bewilderment,
insecurity and confusion are only felt subliminally.
A strange normality and a deceptive calm have become
a maxim for life here, incorporating a large measure
of self-deception and suppression. There is a feeling
that the reality that is, should not be; and that reality
is a formulation of only one possibility in which
historical conditions are manifest. A visit to the East,
reception of GDR television, are concrete
confrontations with another *possibility,* although it
hardly counts as another way of life to be striven for.
The reality of socialism does not represent a genuine
alternative to the reality of capitalism. But it does
accentuate Western life. The modelling of reality –
practised by the mass media, social stuctures, culture
– becomes more transparent both in the East and in
the West. Scepticism and insecurity combine with a
counterflow of emotion and yearning to create a
simultaneity of critical analysis and utopian vision.
This dichotomy finds expression in the art of Berlin
in a complex blend that neither denies the
contradictions of experience nor propounds the
alternative of a better world. Quite the opposite.
This art amplifies the potential for contradiction by
making the principle of confusion its central axis.
This demands that the onlooker acknowledges the
intrinsic insecurity of experience and understands
that art today can only find its support and stability
in a form of instability. For it alone offers a chance of
changing the *status quo* which currently gives
Western society – politically, culturally – the state of
glittering wretchedness.

Sculpture and Attitude:
Olaf Metzel

Of all the fine art media, sculpture is the most public.
Situated in space, it is simultaneously endowed with
the dimension of time. Sculpture cannot be perceived
at a glance. The onlooker must regard it from a large
number of perspectives, constantly changing his/her
attitude towards it. Sculpture therefore supposes
multi-dimensional perception, which triggers a
process of experience. The multitude of perspectives
of one viewer correspond to the many views of
another, making sculpture – notably in a public
place – an object of social experience. Against this
background, sculpture declares its duality: it speaks
about itself, and its own shape, but at the same time
it speaks about the space in which it is displayed and
perceived. But space here is taken beyond the purely
physical dimension. It is historical and social space, a
place of historical experience. It is this quality which
has become a problematic central to 20th century
sculpture. The loss of a uniform image of the world,
the fragmentation of the social experience into many
different spheres, no longer allows sculpture to
speak in the name of a particular social class. This
results in the process which – as in other forms of art
– leads to sculpture as an auto-reflexive
manifestation, with the conditions of its own
appearance as its subject. It can be seen as a release
from the ideological constraints within which
sculpture was forced to exist in the past. But at the
same time – and this is becoming clear today – it
indicates a failure of its social dimension. The
self-preoccupation of formalist sculpture, whilst
appearing to represent freedom, was and is capable
of incorporation within the existing structures of
authority. Its autonomy becomes a mere
appearance, and – ultimately – the embellishment of
a false awareness.

Sculpture of the present day is trying to escape the
muteness of formalism and to find a new language.
This has become a central focus of artistic activity

principally in British art (Cragg, Woodrow, Allington, Deacon, Gormley). What is clear in this is that sculpture is seeking an interface between private and public, an element in which individual perspectives and social context force their way through.

Olaf Metzel is the most trenchant example of this in present-day German art. His work circles around ever-new versions of the tension between the inherent autonomy of sculpture and the relationships it can establish to personal and social experience. His work is a political work, which declares the artist to be a *zoon politicon*, a social being. Subjectivity is bound to the question of social obligation. It is against both the politics of the pure form and the politics of private obsession. **Metzel** does not illustrate any phenomena of *Realpolitik* (realist politics). Equally, he does not formulate any political programmes in his work; but he seeks the attitudes which can be made visible in the interaction of sculpture and political awareness. His **Five-year Plan** takes up an icon of the political economy of socialist societies. The work offers a monument to the glory of *The Plan* as blueprint and guarantee for the establishment of a humanistic social order. The props of emblematic representation make the work a positive symbol. The material content of the work, however, denies such a reading. Cast in concrete, held together by iron reinforcement, the other side of the coin reveals itself. Ossification and bondage are experienced. That which was intended to serve mankind becomes a form of coercion.

The Five-year Plan is a sculptural reflex to experiences which characterise socialist societies. In the installation **Turk's Flat – Deposit 12,000 DM negotiable,** Metzel tackles one aspect of the current mentality in the West, in West Berlin and the Federal Republic. **Metzel** rented a flat in an old building in Kreuzberg where the owner had evicted a Turkish

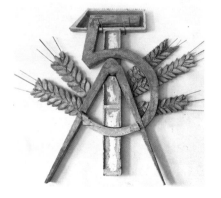

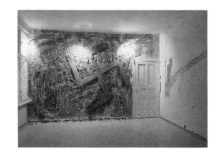

family. Here he addresses xenophobia, which for **Metzel** is intimately linked with the ideology of the Nazis and their racism. Into one wall of the flat he cut a swastika. It can be compared to the fiery writing on the wall of Nebuchadnezzar, *Mene tekel upharsin,* in the Book of Daniel. Sculpture has become political analysis and warning. The repositioning of the swastika within this context adds a new and poignant resonance to its aggressively direct iconography.

26

In the **Study of Oak Leaves,** Metzel gathers the heroes of European culture. Plaster casts of Voltaire, Alexander von Humboldt, Gilly, Beethoven, Mozart, Lessing and Nietzsche are displayed in a glass case alongside the German national emblem of *oak leaves.* But the heads have been destroyed, brutally mutilated with a circular saw. The work explores the complex and contradictory nature of cultural memory, our appraisal of the past, its values – most specifically of the utopian Enlightenment – and traditions. **Metzel** peels away official veneration of tradition to reveal the true face of history.

30

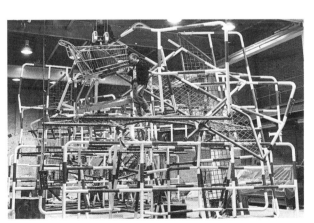

If this work is concerned with history, his gigantic sculpture **13.4.1981 (February 1987),** created for the *Sculpture Boulevard* on the Kurfürstendamm in Berlin on the occasion of the city's 750th anniversary, deals with the present. Metzel erected a 12m high structure which took as its prototype a collection of found objects – police crowd-barriers, paving stones and a supermarket trolley piled on top of each other – the detritus of a demonstration **Metzel** photographed 1981. This sculpture is situated at the same place – one of the busiest crossroads in Berlin – as the original model. The date in the title of the work reconnects this monumental sculpture to original clues of disruption and the event itself to give an explosive resonance. The demonstration to which **Metzel** is referring was staged after a tabloid newspaper reported the death

12 of a German terrorist on hunger strike. In fact, this report was a deliberate hoax. Its purpose was to provoke riots, and to compromise the reigning (Social Democratic) Berlin Senate by their handling of such a crisis. Sculpture here also refers – to paraphrase Joseph Beuys – to the *sculpting of the consciousness* as performed by the mass media. The supermarket trolley can also be seen therefore, as a reference to one cause of social contradiction. Capitalism as an ideology of social partnership is simultaneously a potential vehicle for violence.

In the work which **Metzel** produced specially for the ICA **13.4.1981 (April 1987)** this aspect is brought to the fore. The crowd-barriers are confronted by a gun, which can function as a counterpart to the Berlin supermarket trolley. What was originally a sculpture in a public space relating specifically to the context of Berlin has now come to represent a general fact of Western institutional democracy.

Metzel's work is not only important to postwar German art; it provides a pivotal contribution to the arena of public sculpture. It gives sculpture back its public voice, which in its directness accords with the political experiences of today. Sculpture is coming to embody conflict, counteracting the domestication of art into formalism or the subjective fetishism that currently dominates the art scene.

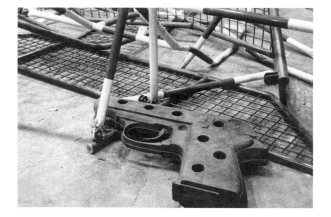

**Exoticism and the Everyday:
Gerd Rohling**

That reality is always experienced only as one
interpretation of reality – and then only in the form
of a possibility – has become a condition of modern
art. Culture is undergoing a process of confusion,
intensified by the experiences of the media – mainly
television and films. It must react to the mass media
increasingly fictionalising reality, blurring the
boundaries between real experiences and fictional
constructions. That which does not fit into the
framework of entertainment no longer has any
chance in the final analysis of being assimilated by
the mass media. Neil Postman, the New York media
critic, who follows in the footsteps of Marshal
McLuhan, has drawn attention to this problematic
situation in his book *We are Amusing Ourselves to
Death*. The phenomenon of simulation is
increasingly determining our view of reality. The
self-representational rituals of political systems
show that simulation is directly related to the
establishment of power structures.

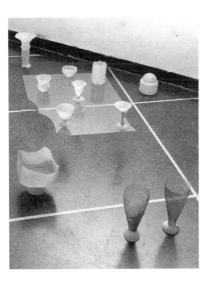

Fiction and simulation can be said to be elements
central to the work of the Berlin artist **Gerd Rohling**.
This extends from the presentation of simple things
to large panoramic designs of exotic scenes. In his
works **Roma** and **Bologna,** Rohling presents articles
found in everyday life with a minimum of
intervention. With a few cuts and by their
presentation in a glass cabinet, they are transformed
into precious vessels which become luxury objects in
the tradition of artistic craftsmanship. Only a careful
look at these objects reveals that they are not
valuable glasses and bottles from the history of
culture, or the world of contemporary design. The
(modified) everyday object is given the lustre of a
work of art and becomes the recipient of multi-
layered associations. One of these opens up a
cultural historical dimension: value as a corrolary of
time. A simple clay vase made 2,000 years ago is
today an object of culture. The plastic bottle of today

cannot achieve this standing. At the same time this work articulates the significance of supply and demand. If plastic were a rare substance, articles made from this material would have a special intrinsic value. But they achieve this today purely through the context of art.

If in Roma and Bologna Rohling makes a minimal excursion into the world of everyday articles, other works display a poetic transformation of the everyday. The **Avant-Garde** series consists of gas bottles, deftly sawn up to become, for example, Indian heads. The proverbial *eagle eyed* vision of the Red Indian is transmuted directly into a visual metaphor as a shaft of wood literally projects from the head's eye. **Rohling** uses a similar process for oil cans and drums. An insignificant article is always transformed to become an exotic object, which however, does not deny its trivial origins. But it is **Rohling's** huge picture panoramas and relief works which above all lead from the everyday into the realm of exoticism. Like frozen film-stills, they seem to pull the viewer subconsciously into their own scenery. The nearly 6.5 metres long relief sculpture, clearly alludes to film in its title: **The Third Man**. But the relationship is not so much with Orson Welles as the Third World. The body of an Indian woman rests under a black sun or a black moon. She is shown sleeping, protected by a felt cover (a material pregnant with meaning in German art due to Beuys). The work radiates an enormous tranquility which demands a slow, meditative reading, creating a psychic state which echoes the trance-like contemplation of a loved-one. The other world of the sleeper enters into a relationship with the perceptual world of the viewer. The spectator discovers her/himself as projecting thoughts/feelings on to the inanimate object. The dichotomy of 'reality as possibility' occurs again. Here, it is not only the strange world of a strange culture, but also the

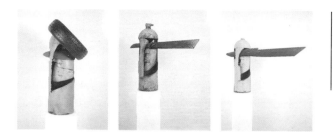

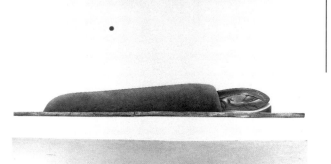

Tribute to Joseph Conrad 1986
Wood, paint
30×220×20cm

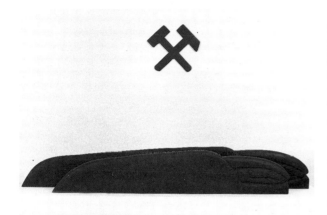

strange world of sleep. In **Tribute to Joseph Conrad,** the subliminal element of the relationship is moved into the foreground. Two black, almost identical figures, distinguishable only by size, rest under the steadfast sign of the *Coal-and-Steel Community* (Montanunion). The onlooker brings them into a dreamlike relationship which is established in relation to her/his wakefulness.

The exoticism in **Rohling's** work, which clearly embodies elements of romanticism, is simultaneously set in the everday. Both **Rohling's** use of materials – *objet trouvée* – and subject matter – the theme of sleep emerges time and again – illustrate his concern with the commonplace as arena for art. Sleep, most basic of human activities, provides at the same time an exotic experience available to anyone, an experience where we may encounter ourselves as strangers.

15

Body Language and Painting:
Ina Barfuss

Ina Barfuss is one of the few West German women artists who have been able to assert themselves since the comeback of painting at the end of the seventies. In Germany painting is still the preserve of men. While women artists have gained recognition in other media – such as video, film, performance, photography – women are still outsiders in the medium of painting. In no other genre – with perhaps the exception of sculpture – has traditional role consciousness become as rigid as in this medium. The pictures of Ina Barfuss address this problematic, yet incorporate the subject into the more general question of the relationship of the sexes. However, Barfuss does not illustrate these relationships; rather, she looks for pictorial codes for dependency, and repression – but also for happiness. As with Olaf Metzel therefore, the complete work of art must be regarded as a complex formulation of attitudes. Central to Barfuss' work is the notion of **body language,** also the focus of a triptych of the same name. The body becomes a symbol whose meaning the viewer must approach associatively. Grotesque physiognomic distortions create nightmarish scenes which induce a singular tension between fear and objectivity; private nightmare becomes cool conceptual analysis. Her animalistic heads and bodies are absurdly fused together, yet presented as a true reflection of reality.

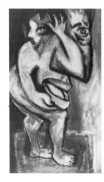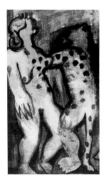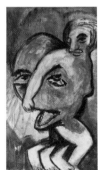

In this they resemble the iconic images of the Middle Ages, or the Renaissance use of emblems. Archetypal elements, religious allusions, and experiential and intellectual clichés are suggestively interwoven. Yet the human image that Barfuss evokes is one that is totally imbued with the actuality of the present day. In her work she liberates us from the repressive imagery that dominates our media-saturated society.

The actual surface of the paintings plays an important role here. Powerful outlines are contrasted by an almost tender use of colour,

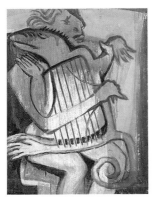
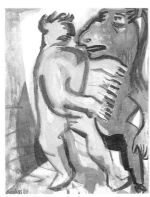

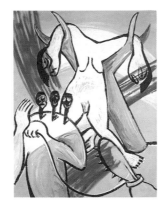

creating an atmospheric ambience for the subjects with earthy, often washed-out, sometimes grubby, tonalities. The pictorial language is governed by an ambivalence which expresses itself in the work as *mixed feelings*. In the diptych **German Music I, II** horror is added to the pathos of art. Nature, the animalistic, penetrates into the realm of culture, a relationship which connects not just the theme of sublimation but also that of art and crime, as in the *'culture'* of the Nazis. But the disasters of mankind, which the pictures of Ina Barfuss address, pass without accusation, self-pity or sentimentality. The whole issue of the relationship between the sexes, still characterised today by repression and exploitation, is made grotesque.

The painting **Holy Ignorance** can be interpreted as a complex *mise-en-scène* posited on the situation of women in patriarchal society. By imposing his system of values the man has driven the woman into schizophrenia. He sacrifices, crucifies her. But a contemporary reading of the picture does not stop at this bald statement. It also makes clear that the man of today knows exactly what he is doing to the woman. But instead of drawing liberating conclusions from this, he flees into another attitude. He surpasses the dichotomy of the woman by showing himself with three (tiny) heads. He tries to outdo her victimisation by masochistic manoeuvre. Ironically, however, the strange dog/club/phallus which he carries as an emblem of power, becomes faintly ridiculous, reading as hollow impotence. The picture presents this visual fable as grotesque story. Yet despite its maliciousness there is an element of black humour, unfathomable, cataclysmic laughter, which makes the imagery bearable. Analytical awareness is paired with surrealist fantasy. The works are freed therefore, from submersion into the subjectivity of an individual confession. What is sought is the objective, which can only be brought to discussion today through the genuinely subjective.

18 | This impulse finds its social dimension in the communal pictures which **Ina Barfuss** has produced for the last ten years jointly with **Thomas Wachweger**. Two subjectivities pervade these pictures, on which both artists generally work at the same time. Together they seek an *other* which does not delineate two identities but rather creates a third, discrete entity, which stands both as the work of art and its own critique.

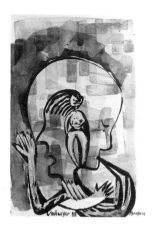
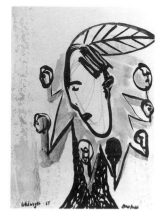
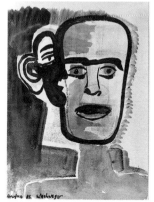

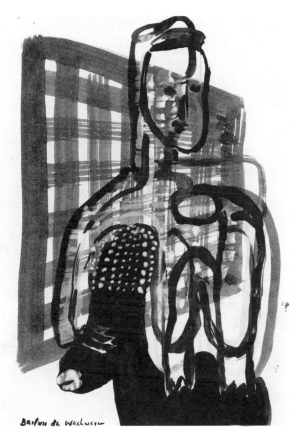

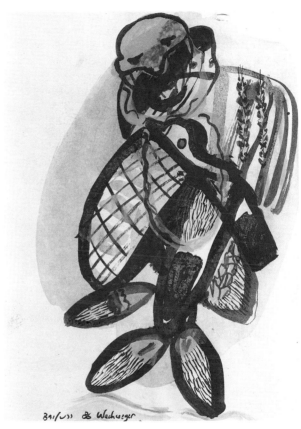

Pictures and Politics:
Thomas Wachweger

Whereas in Ina Barfuss' body language the quest for a
general visual code for human relationships is at the
foreground of her work, the themes of politics and
history dominate the paintings of Thomas
Wachweger. Here too, however, both elements in the
picture refer to personal experience. Wachweger is
not concerned with explanations but with recording
states of awareness, which extend far beyond the
historical phenomena they address. While historical
painting shows the outer skin of history, Wachweger
attempts to represent an internal landscape with
which the painter himself is inextricably linked. He
does not approach the historical as the exclusive
province of either the subjective or the objective.
Rather he combines the two into a kaleidoscopic
fusion, which draws the past into the present, and
simultaneously charges the present with the past.
The resultant sense of bewilderment denies a
didactic reading of history. Wachweger will not act
as preacher or arbiter of social conscience, instead he
triggers a plurality of associative interpretations
both private and public.

Central to Wachweger's work is a relationship with
the past, its hopes and failures, and those
particularly of German history. For him, images can
constitute a **journey through time.** In a work of the
same name, subtitled **'Ezra Pound'** he links this to
the persona of the artist and intellectual. Man stands
endangered, caught between the past (as represented
here by the ignorance of the donkey) and the present
(the disappearance of nature into digitalised
characters). For Wachweger, Ezra Pound is an
associative example of this. What future this is
leading to remains totally open.

A look into the past can also be discerned in **German
Teacher Erdmann Explains the World.** A gereatric
schoolboy with a rifle, a grotesque figure, is sitting in
front of a wall on which grinning Death can be
recognised. The notions both of patricide, and of the

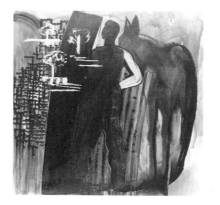

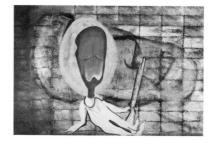

Oedipus complex are undercurrents here; as clearly, if one knows the preoccupations of **Wachweger's** work – are his references to German history. Postwar Germany immediately tried to liquidate its past. We have here then, the patricide of history, committed by the son who is, however, totally lacking the maturity of adulthood. For **Wachweger** this picture is also linked to aspects of his biography, his scholastic education. He therefore channels the personal into an image dealing with the broader concerns of the national past. Other paintings, in contrast, allude directly to political facts. But it must be added that **Wachweger's** way of working is a kind of process in which themes crystallise by and by. The pictorial structure evolves from an initial intuitive markmaking. To this are added (visual) associations, which supplement the work at many different levels. A title for the work is usually found at the end, and can itself operate on a variety of levels. **The Party is Always Right (and good evening to you)** combines the political slogan of the Socialists with an everyday colloquialism. **Wachweger's** images tend to be emblematic: the eponymous *Party* is resolved into two bizarre components – an oarsman and a bowlful of skulls (a German idiom for *exercising authority* is, literally *to come to the rudder;* similar to *to take the helm* in English). The title and emblems combine to represent authoritarian ideology. Bearing the bowl of skulls is the figure of a woman, superimposed onto the legs of the oarsman – politics combines with eroticism. Closer examination, however, reveals the woman to have bleeding hands and feet. The immediacy of the second part of the title acts as a balance against the weight of history charging the painting. It also directly addresses the viewer, drawing them into a direct interpolation with the image. **Wachweger's** pictures depict a fake reality. Any cosy view of art as vehicle for escape or relaxation becomes impossible as the spectator is provoked into a shifting and heterogenous range of responses.

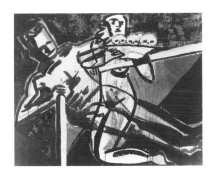

22 Whether **Mater Dolorosa, Blinding,** or **The Animal Inside You,** the works are always structured as visual stimuli for multi-perspectival associations. Psychoanalysis (Oedipus) is joined with myth (Polyphemus); national identity (Imperial Eagle) with religion (Madonna); nature (animal) with culture (picture). **Wachweger** is seeking – according to the title of a painting – an *Inbetween State*. For art which has the power to be effective can only arise from this arena because it then not only reflects reality but has the power to change it.

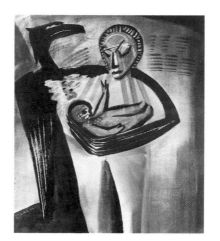

52

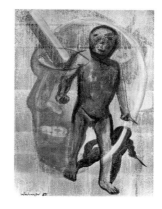

54

53

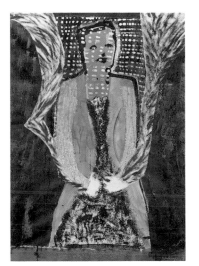

The works of **Metzel, Rohling, Barfuss** and **Wachweger** can indeed be related to the experiences which characterise life in the schizophrenic context of the city of West Berlin. The contradictory is here paired with the desire for exoticism, for other states. Analytical thinking combined with associative awareness. A complexity of themes and art forms predominate, and deliberately oppose the quick obsolescence of neo-styles. But, stamped by the character of this city, these works move from the particular to the universal, dealing with issues arising from the totality of the context of art and the public today. What has been shown here is not a *Berlin's-eye view* of the world. It is a view provoked by Berlin, and which soberly, cynically, and affectionately circles around the theme of the present, as the eye looks over objects in order to comprehend them in their fullness. The work of art is a stimulus for change, but with the power of contradiction. Karl Scheffer wrote in 1911: *'Berlin has been damned to the fate of always becoming, and of never quite coming to be.'* It still applies to Berlin today. Especially to its art.

23

**Excerpt from a discussion
between Ursula Frohne and
Olaf Metzel** January 1985

24 **Ursula Frohne:** Looking at your relief works, one can't help being reminded of political murals.

Olaf Metzel: I started out by getting involved in that sort of thing. But I never felt they expressed the harshness I was looking for, so I thought it was better to just slash them, rip them up. If you've grown up in a city, it feels right to treat the material as if you're ripping a piece off the corner of a house-wall.

UF: But you wouldn't admit to being involved in political art?

OM: No. Why should I? Saying nothing is a statement in itself. Take the swastikas you find in any public toilet . . .

UF: But in your 'Turk's Flat' we are confronted with a statement on racism and housing policy. You must agree that the huge swastika provides us with an immediate connection between the terror of the past and the spell it still obviously casts over current developments.

OM: I did that piece three years ago when the first gentle hints of racism were coming to the surface. A remark made by Lummer, the Senator for Internal Affairs, was what set the ball rolling for me. He more or less said you could smell Turks a mile off. That struck me as a very interesting remark. So I looked for a place where Turks actually had been living and rented it in the normal way. Then I thought I'd set it up as though our eyes were the blade, and mounted a video camera on the cutting plate. I made a 2½ minute video and set it to the sound made by space-invader machines in amusement arcades, so as to make it a film of hatred, to make people let off steam after watching the news on television. What I didn't want was an art video.

UF: More like a video piece, then?

OM: Yes, exactly. Then I thought I should do the whole thing properly and splash the object all over the media – in the form of film, photography, sculpture and in newspapers, and integrate it totally into the living context. The end product was the advert in the daily paper which read 'Turk's Flat,

12,000 Mark deposit, negotiable'. It invited people to look around the flat instead of come to a private view. In place of the fridge, carpet and television, you know, the normal things you have to pay a deposit on, there was the sculpture. What's so political about advertising this flat on the property page?

UF: Whatever you say, you have established a direct relationship to the spirit of the age.

OM: I don't establish that relationship – it just happens. It's like if you pull the communication cord on a train and it stops for a moment.

UF: Don't you plan your pieces a long time before you get to the place where you're going to exhibit?

OM: Sometimes. Sidney was improvised, so was Stuttgart . . . I made a brief sketch on the spot of what it might look like, just to get a feel of how I was going to manage it. You see, I don't have much time to think things over once I've started my machine up. At 12,000 rpm I have to get it right first time.

UF: But don't you ever feel uneasy about being in a strange place and having to find a suitable object when the time is short?

OM: No, in those situations I find I can get down to the essential aspects of my work more quickly. Besides, if you come from Berlin you have a certain instinct for things that are ruined.

UF: The widely acclaimed freedom and the great variety of life-styles to be found in Berlin have seen better days, haven't they?

OM: You're right, the sparkle has gone out of the place. There's a tangible sense of discontent. But then West Berlin always was about to blow a fuse. Of course, it's pleasant living here. There's no curfew, and you can stay out until the early hours. I do enjoy that, but it's a private pleasure. The official crap doesn't interest me. What I find interesting about Berlin is what I call 'the proximity to the distant'. By going over to the East, I have the opportunity for immediate change. When I was

a kid I played more in the East than in the West. Whenever I do go over, it's as though someone has turned back the clock. It's exciting to be able to wander around over there and not see any brightly coloured graffiti, for example, but instead only find things that people have scratched into walls with their fingernails or with a piece of chalk, simply because they can't afford paint. That's actually much harsher. I find it more convincing because it's both more archaic and more anarchic. The things that are going on in West Germany are quite different. While I don't want to stylise what's happening in the East, the rapid switch between East and West does give rise to a genuine range of contrasts. This is what I mean by 'proximity to the distant'.

UF: Your position as an artist is one of extreme unsentimentality and lack of compromise.

OM: Perhaps that arises because I destroy many of my pieces. They are meant to be momentary intrusions. Like a sequence of images.

UF: So you don't merely accept destruction as a natural phenomenon, but you pursue it deliberately and consistently.

OM: Yes. But plastic explosive is too crude for my taste. The system operates in far too subtle a way. Yet, when I look around, I find most of what I see is misunderstood style presented with great self-confidence. A bit more anarchy and nihilism wouldn't come amiss . . .

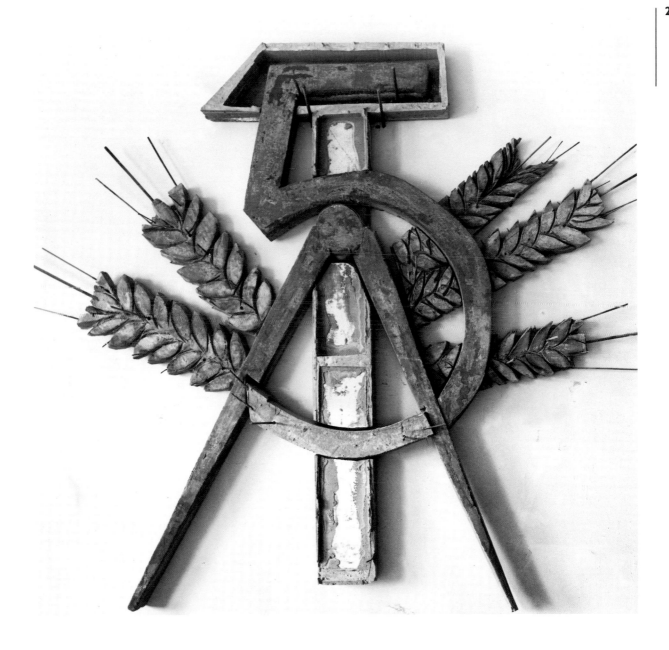

26

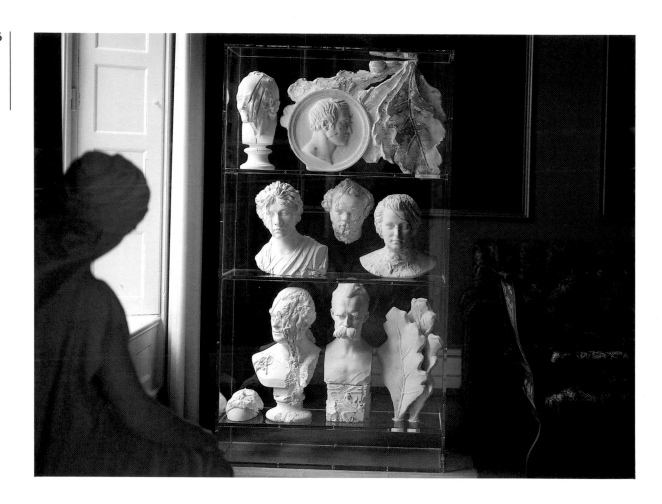

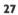
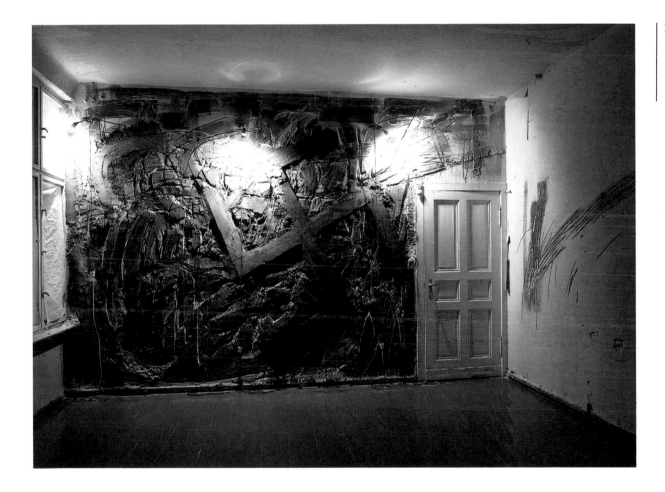

Tankstelle Landsberger Str. 193 (B 2) 1982
(Petrol-station Landsberger Str. 193 (B 2)

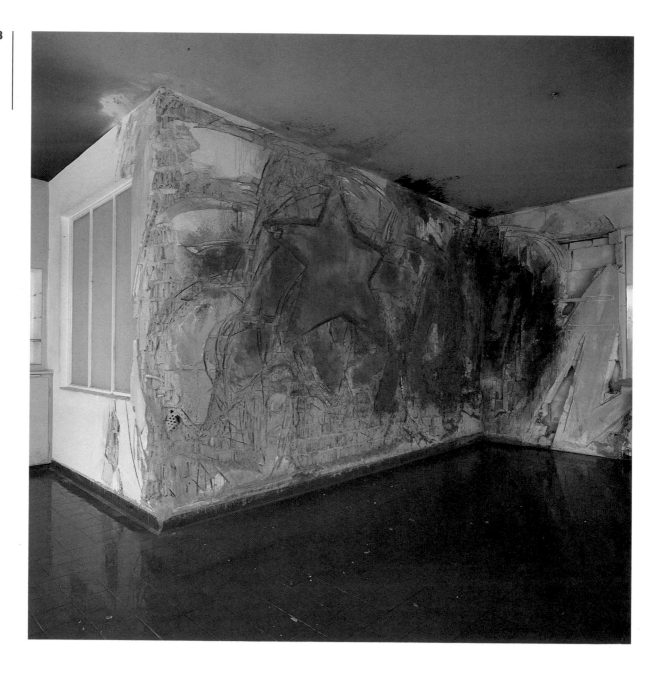

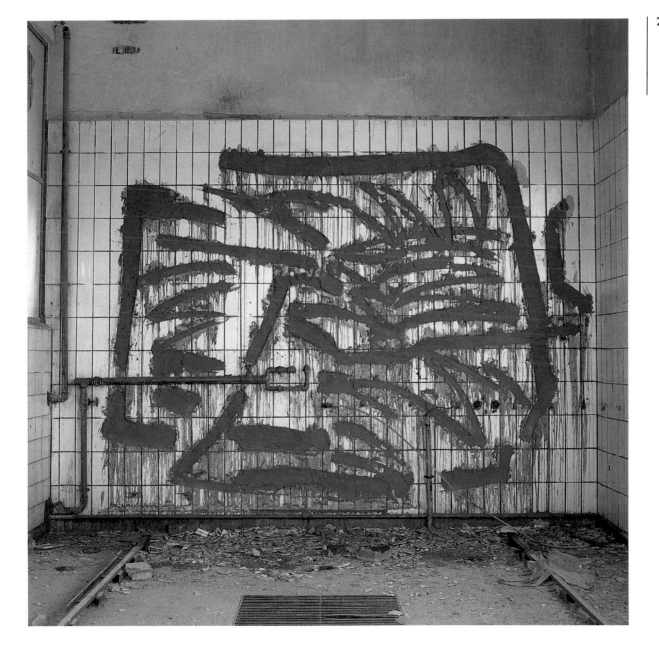

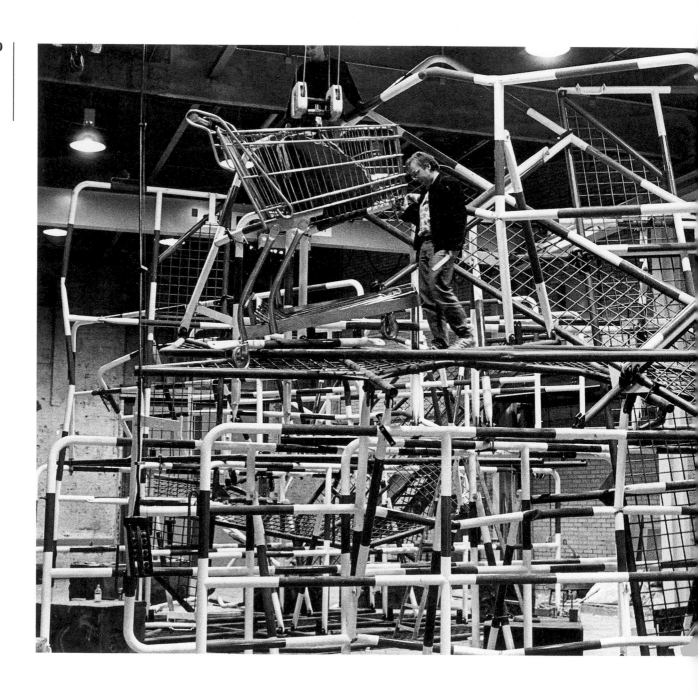

1952
Born in Berlin
1971-77
Studied at the Free University, Berlin and at the Academy of Arts, Berlin. Graduated with title of Master Student (Meisterschüler)
1977-78
German Academic Exchange Service (DAAD) grant for study in Italy
1983
Cultural Association of the Confederation of German Industry Scholarship and a grant from the Senator for Cultural Affairs in Berlin
1986
PSI residency, New York
Kunstfonds grant, Bonn
Visiting lecturer at the Hamburg Academy of Fine Arts
1987
Villa Massimo Prize, Rome
Glockengasse Prize for Art, Cologne
Lives and works in Berlin

Solo Exhibitions
1981
Skulptur Böckhstr. 7, 3.OG, Berlin
1982
Türkenwohnung Abstand 12.000DM VB, Berlin
Tankstelle Landsbergerstr 193 (B2), Kunstraum München, Munich
1984
In die Produktion, Dyckerhoff & Widman, Neuss daadgalerie, Berlin
1985
Olympische Kunst/Fünfjahrplan, Künstlerhaus Bethanien, Berlin
Saalbau (mit R Kummer), Berlin
Flaschen und Nummern, Galerie Fahnemann, Berlin
1986
Merdre, Michael Schwarz, Brunswick

Group Exhibitions (selection)
1981
Bilhauertechniken, Kunsthalle Berlin
Forum Junger Kunst, Städt. Galerie Wolfsburg; Kunstmuseum Düsseldorf; Kunsthalle Kiel
Situation Berlin, Galerie d'Art Contemporain des Musée de Nice
1982
Gefühl und Härte, Kunstverein Munich; Kulturhuset Stockholm
1983
Montevideo Diagonale, Antwerpen
Künstler-Räume, Kunstverein Hamburg
1984
Private Symbol: Social Metaphor, 5th Biennale of Sydney
Kunstlandschaft Bundesrepublik, Württembergischer Kunstverein, Stuttgart
von hier aus, Zwei Monate neue deutsche Kunst, Düsseldorf
1985
Margirus 117, Kunst in der Halle, Ulm
Drawings, 12 artists from Berlin, Goethe Institute Cairo, Tel Aviv, Athens, Sarajevo
Dem Frieden eine Form geben – zugehend auf eine Biennale des Friedens, Kunstverein Hamburg
1945 – 1985 Kunst in der Bundesrepublik Deutschland, Nationalgalerie Berlin
1986
Berlin Aujourd'hui, Musée de Toulon
Jenisch-Park Skulptur, Hamburg
Momente, Kunstverein Brunswick
1987
Skulpturenboulevard, Berlin
Berlinart 1961 – 1987, Museum of Modern Art, New York
Skulpturenprojekte, Münster
documenta 8, Kassel

Excerpt from a discussion between Ursula Frohne and Gerd Rohling January 1987

Ursula Frohne You have called a certain group of your works 'The Avant-Garde'. The inflationary use of the term has rendered its actual meaning increasingly imprecise. Originally it signified a grouping or movement which passionately fought for its ideas. Are these figures protagonists of a vanguard which you feel is called for?

Gerd Rohling: Yes, I took the term 'avant-garde' literally. It is society that ultimately determines who belongs to the avant-garde. This seems to be a situation worth challenging. I want to be the one who decides what or who is avant-garde. For me these figures are the avant-garde. I feel it's much more logical to employ this kind of representation than to search for a verbal formula. So it could be seen as a naive approach . . .

UF: . . . orientated predominantly towards externalities, conspicuous styling? After all, the impressive uniforms and the strident profiles of the 'champions' do suggest militant resolution.

GR: Yes, which is quite apt. Chin guards, mouth guards, masks, glasses, hats and earrings all recall legendary heroes like Zorro. It's my romantic notion of the fighter that extends to include current political debates on disguises worn by demonstrators and so on. Though actually their struggle can be seen in the expressions on their faces. You don't see weapons anywhere, simply an attitude – both in the individuals and in the group as a whole. They are all looking in one direction, a movement can be felt to be lurking in there. And that is the crucial thing – nobody's looking back, they cannot but go forward. It's almost like going into battle.

UF: Hero-like villains, noble-minded outcasts – are these the models for your 'avant-gardists'?

GR: Yes, monuments have been built to these people far too rarely. Elegance and the right costumes are part of it too. They have to look wild and possess beauty at the same time.

UF: The attraction of the alien and the exotic nature of untamed beings are motives which are heavily laden with eroticism, and which make themselves felt in the metamorphoses of animal and human physiognomies.

GR: I agree, though they are important formally too. Of course, the types we're talking about mark out a quite definite border area. They are works of art, but something else besides. They could be beautiful motorcycles too. Somehow they pose a challenge, as if they were inviting you to dance . . .

UF: Is charisma a criterion of your understanding of the avant-garde, a sphere beyond art? As in, for instance, the discussion in recent years which has ended up by transcending the limits imposed by the traditional, linear conception of the avant-garde?

GR: I'm not interested in the discussion. I also don't regard my work as avant-garde – it's my figures who are the avant-gardists. In this way I have proved that the avant-garde exists. Because, you see, for me the term stands for something different. It stands for people, who by their very existence, are art themselves, who are timeless and thus more beautiful than works of art. Besides, they have that expression on their faces.

UF: A bold expression?

GR: Many people's expressions appear bold at first, but they lack intensity. The fact is that there are those in whom the two are identical – and they don't have to be artists. I'm talking about an absolutely genuine attitude, about which there is nothing contrived, which is theatrical and yet close to life. Heads have got a great deal to do with it. Perhaps I have a desire to be like that too. But neither violence nor styling can be involved – the environment has to be right as well. That's why it's also important where the figures stand and how they are arranged. I admit that certain things can be imported from other cultures and other cities, but the object then tends to lose the unique qualities it has when it grows with the architecture, the cars and all that surrounds it.

UF: So your figures propagate avant-garde as a way of life. They possess a natural sovereignity, a pride which is simply present without fashionable adornments.

GR: Yes, like the way Van Gogh painted his postman – his expression is just like a French king's. They're the sort of people who can look straight ahead.

UF: And who show no contradictions within themselves?

GR: That's a condition in the avant-garde set. They must uphold an idea, and believe in it in their heart of hearts. There is something very suggestive about that. You can hear the battle-cry behind: 'Beauty to everything!'

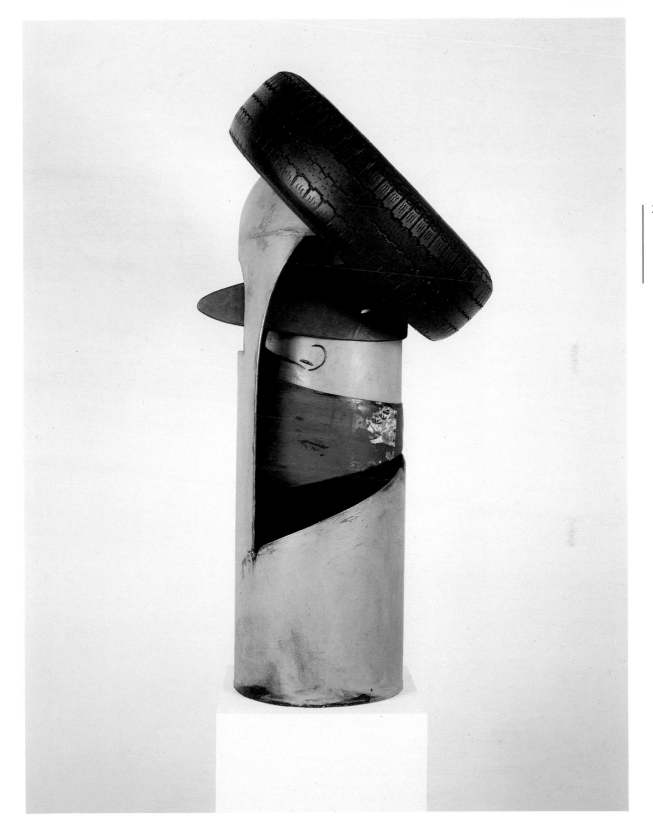

34

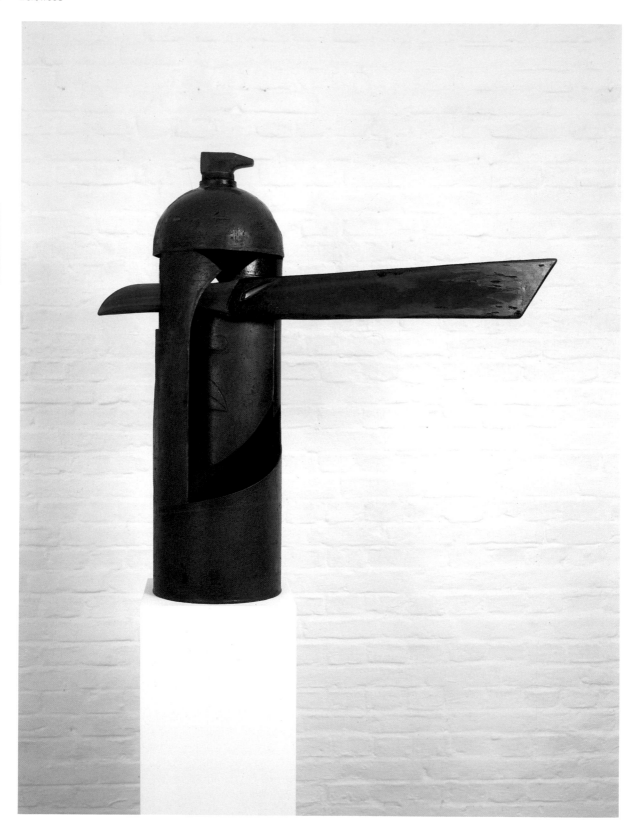

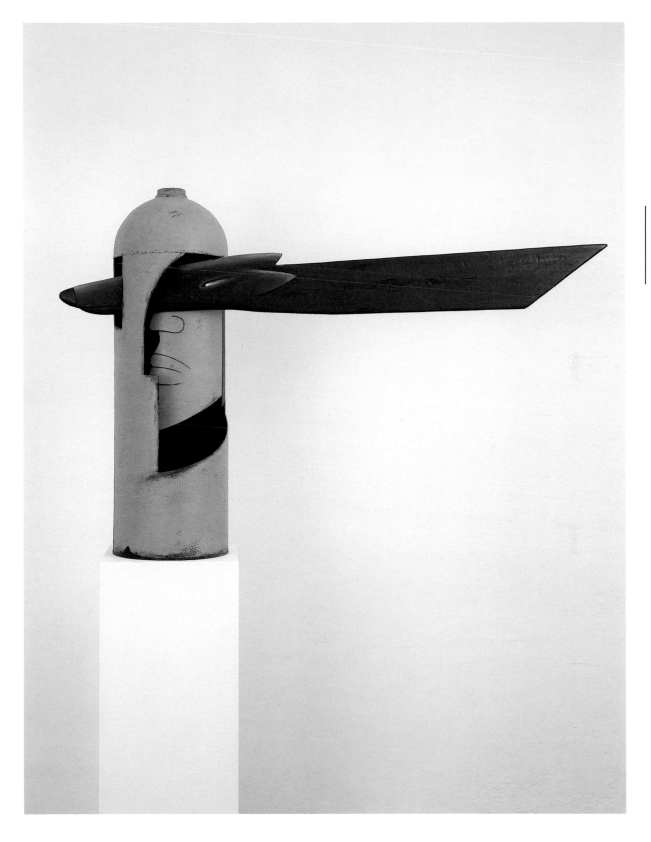

Der Dritte Mann 1986
(The Third Man)
Wood, felt, paint, iron
90×650×10cm

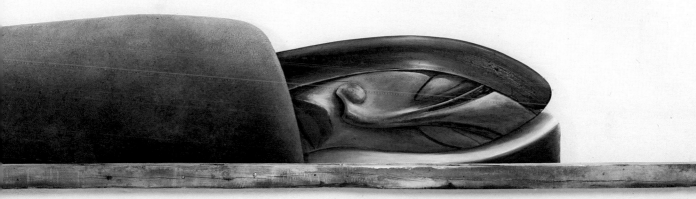

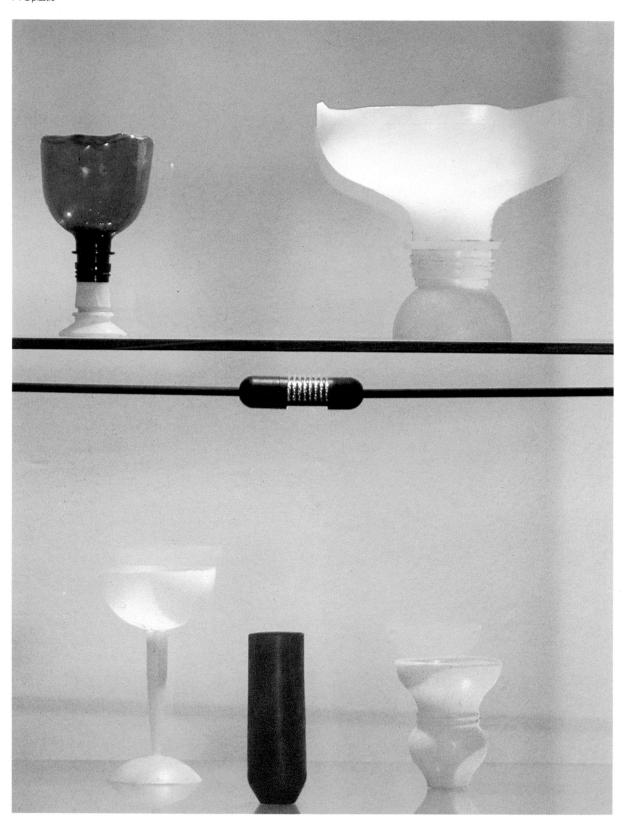

1946
Born in Krefeld
1971-77
Studied at the Academy of Arts, Berlin
Graduated with the title of master student
(Meisterschüler)
1979
Founded group and gallery 1/61
1980
Villa Romana prize, Florence
1981
PSI residency, New York
1982
Kunstfonds grant, Bonn
Lives and works in Berlin since 1971

Solo Exhibitions
1980
1/61, Berlin
Galleria Schema, Florence
1981
Neuer Berliner Kunstverein, Berlin
1983
Freiburger Kunstverein, Freiburg
Galleria Peccolo, Livorno
1984
Galerie Fahnemann, Berlin
1986
Galerie Fahnemann, Berlin

Group Exhibitions (selection)
1981
Situation Berlin, Galerie d'Art Contemporain
des Musée de Nice
Berlin eine Stadt für Künstler, Kunsthalle
Wilhelmshaven
Ars Viva, Kunsthalle Bielefeld
1982
The Clocktower, New York
Gefühl und Härte, Kunstverein München and
Kulturhuset Stockholm
Kunst wird Material, Nationalgalerie Berlin
1983
Sculpture 83, Kunststichting Rotterdam
Montevideo Diagonale, Antwerpen
New Painting in Germany – dimension IV,
Nationalgalerie Berlin; Kunsthalle Düsseldorf;
Haus der Kunst Munich
1984
Neue Malerei Berlin, Kestner Gesellschaft
Hanover
Zwischen Skulptur und Malerei, Kunstverein
Hanover; Haus am Waldsee Berlin
Ein anderes Klima, Kunsthalle Düsseldorf
1985
**1945-1985, Kunst in des Bundesrepublik
Deutschland,** Nationalgalerie Berlin
Drawings, 12 artists from Berlin, Goethe
Institute Cairo, Tel Aviv, Athens, Sarajevo
1986
Momente, Kunstverein Brunswick
Berlin Aujourd'hui, Musée de Toulon
Vorsatz Eins, Galerie Vorsetzen, Hamburg
1870 – Heute, Martin Gropiusbau, Berlin
1987
Ten Painters: Berlin, Crescent Gallery, Dallas
Desire for Life, Touring exhibition through the
Goethe Institutes of the USA

Ina Barfuss

40 | **'I shock them, but if they knew**
 how much they shock me.'
 Katherine Mansfield

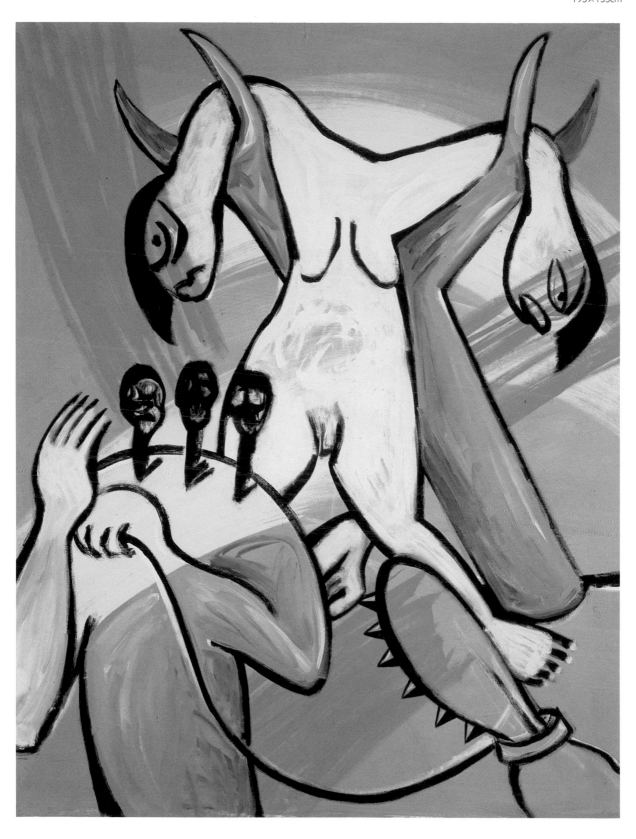

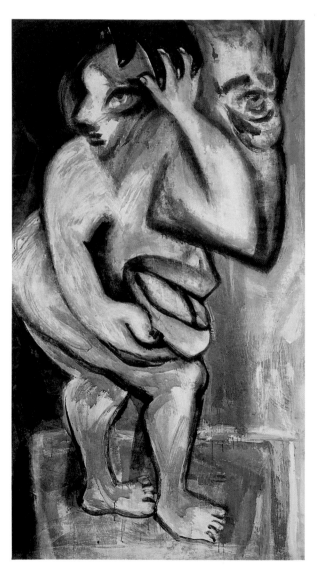
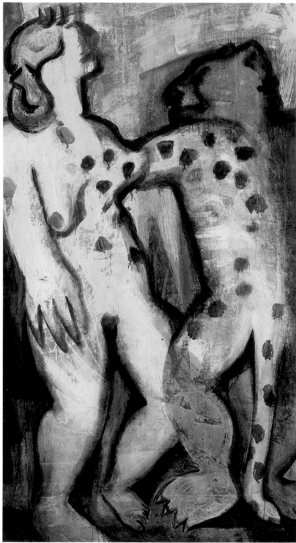

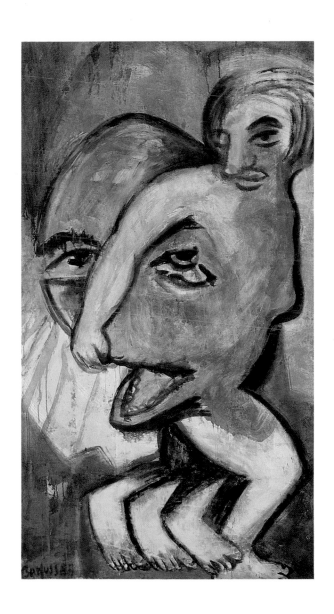

Deutsche Musik I, II 1984
(German Music I, II)
Resin on canvas
200×155cm

44

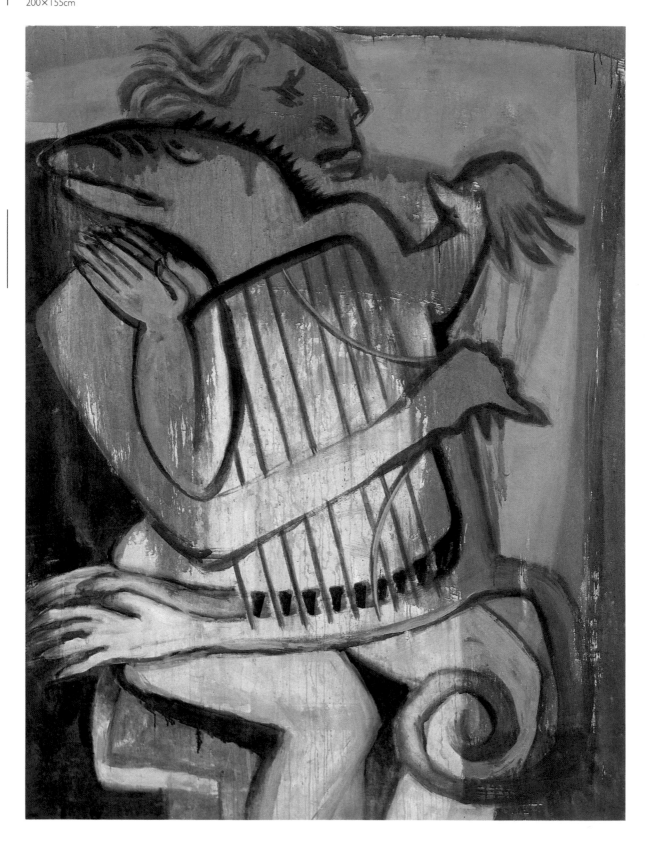

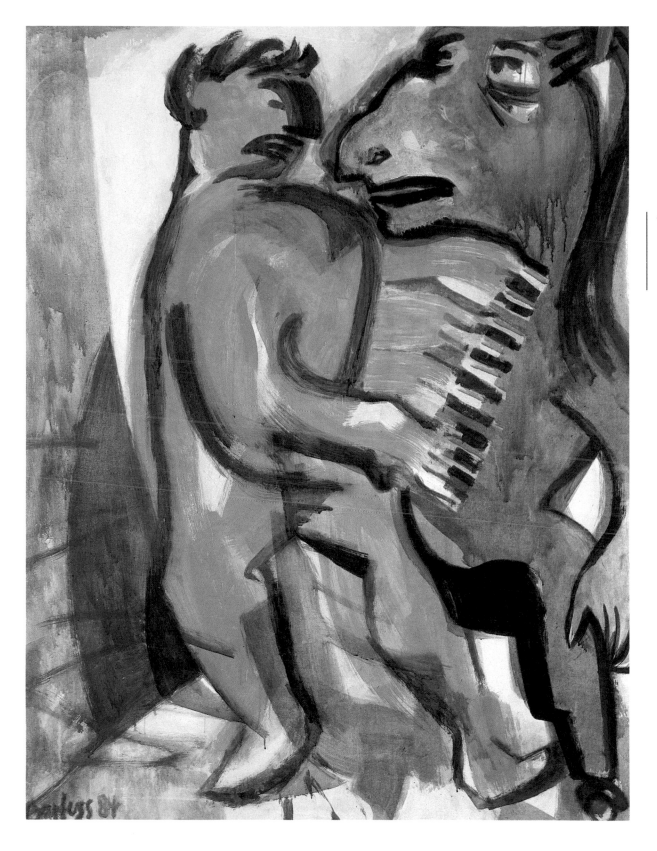

46

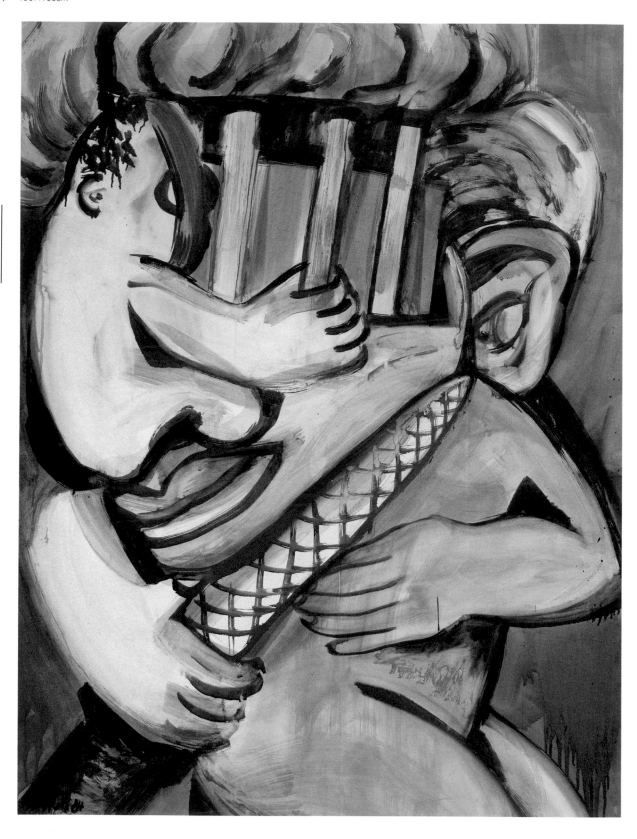

1949
Born in Lüneburg
1968-74
Studied at the Academy for Fine Arts, Hamburg
Lives and works in Berlin since 1978.

Solo Exhibitions (selection)
1982
Der moderne Mensch, NGBK, Berlin
Galerie Six Friedrich, Munich
1983
Galerie Monika Sprüth, Cologne
1984
Galerie Springer, Berlin
Galerie Munro, Hamburg
Galerie Schneider, Konstanz
1985
Die Kunst der Triebe, Museum am Ostwall,
Dortmund and Ulmer Museum (with Thomas
Wachweger)
1986
Haus am Waldsee, Berlin (with Thomas
Wachweger)
Silvio Baviera, Zurich
1987
Galerie Monika Sprüth, Cologne
Goethe Institute, Paris

Group Exhibitions (selection)
1980
Galerie Paul Maenz, Cologne
1981
Rundschau Deutschland, Munich and Cologne
Gegen-Bilder, Badischer Kunstverein, Karlsruhe
Galerie Petersen, Berlin
1982
Über 7 Brücken musst Du gehen, Kutscherhaus,
Berlin
La Giovane Transavanguardia Tedecsa,
Galleria Nazionale d'Arte Moderna, San Marino
1983
Galerie Six Friedrich, Munich
Trigon 83, Graz
Ansatzpunkte kritischer Kunst, Bonner
Kunstverein, Bonn
1984
Wer überlebt, winkt, NGBK, Berlin
Zwischenbilanz, Joanneum, Graz; Villa Stuck,
Munich; Rheinisches Landesmuseum, Bonn
Tiefe Blicke, Hessisches Landesmuseum,
Darmstadt
von hier aus – 2 Monate Neue Deutsche Kunst,
Düsseldorf
Neue Malerei Berlin, Kestner Gesellschaft,
Hanover
**Die Wiedergefundene Metropole (La
Metropole Retrouvée),** Palais de Beaux Arts,
Brussels and Leverkusen
1985
Galerie Munro, Hamburg
Kunst mit Eigen-Sinn, Museum moderner
Kunst, Vienna
**1945-1985, Kunst in der Bundesrepublik
Deutschland,** Nationalgalerie Berlin
1986
New German Art, Museum of Portland, Oregon
Drawings, 12 artists from Berlin, Goethe
Institute Cairo, Tel Aviv, Athens, Sarajevo
Macht und Ohnmacht der Beziehungen,
Museum am Ostwall, Dortmund
Global Dialog, Primitive and Modern Art,
Louisiana Museum of Modern Art, Humlebaek
Berlin Aujourd'hui, Musèe de Toulon
Eva und die Zukunft, Kunsthalle Hamburg
1987
Wechselströme, Bonner Kunstverein, Bonn
Momentaufnahme, Kunsthalle Berlin
Berlinart 1961 – 1987, Museum of Modern Art,
New York

47

Thomas Wachweger

48 | **'I have no desire to be the dung
that fertilises the future
harmony of the earth.'**
Ivan Karamasov

Die Partei hat immer recht ('nen schönen Abend noch) 1983
(The Party is always right – and good evening to you)
Mixed media on paper on canvas
150×184cm

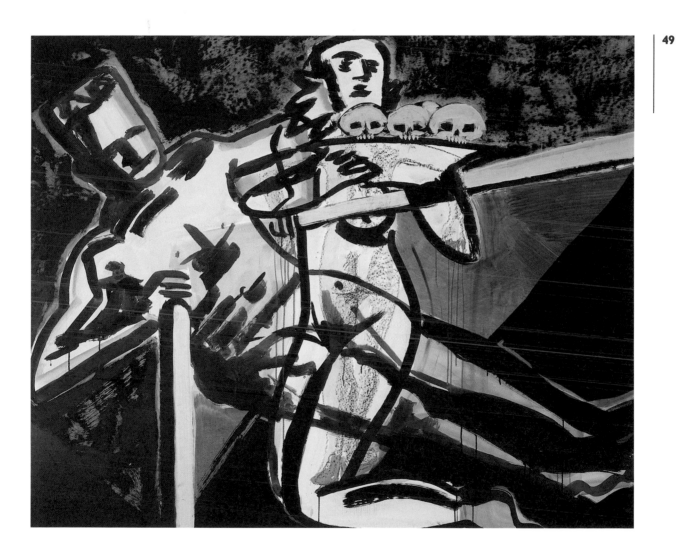

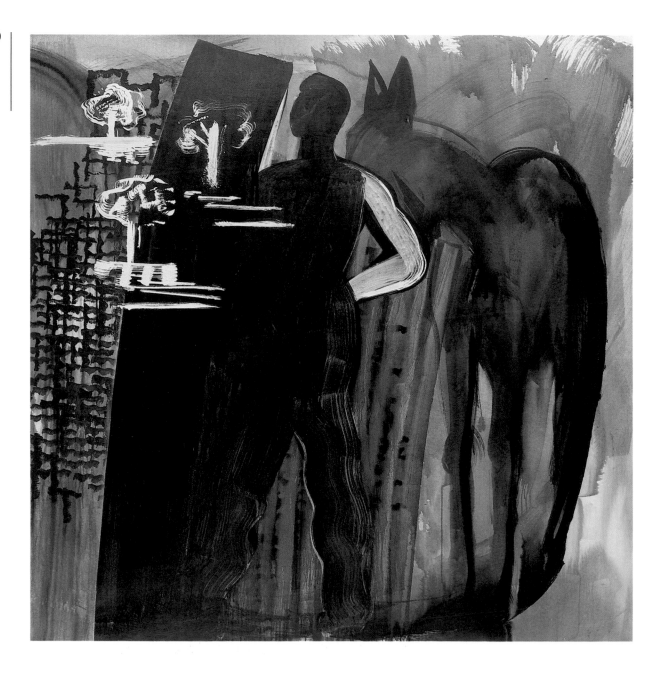

Deutschlehrer Erdmann Erklärt die Welt 1984
(German Teacher Erdman Explains the World)
Mixed media on canvas
160×230

51

Mater Dolorosa 1984
Mixed media on canvas
195 × 175cm

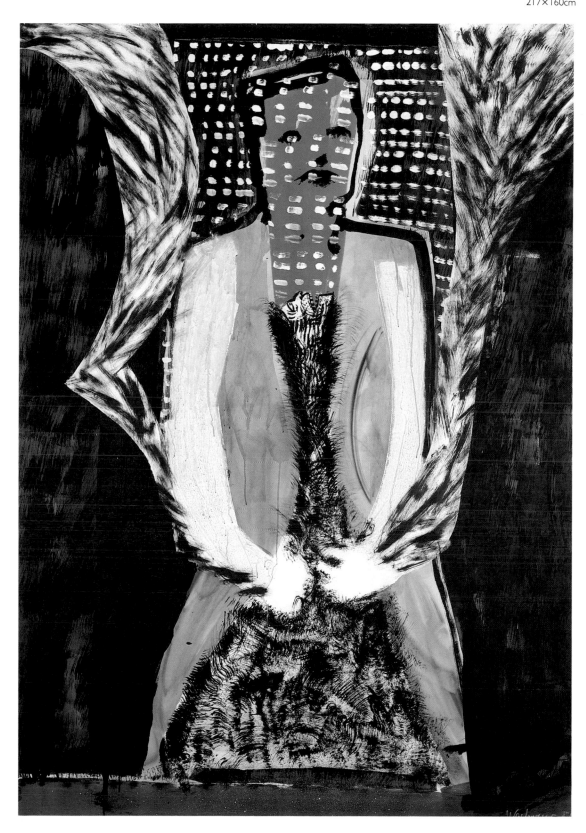

54

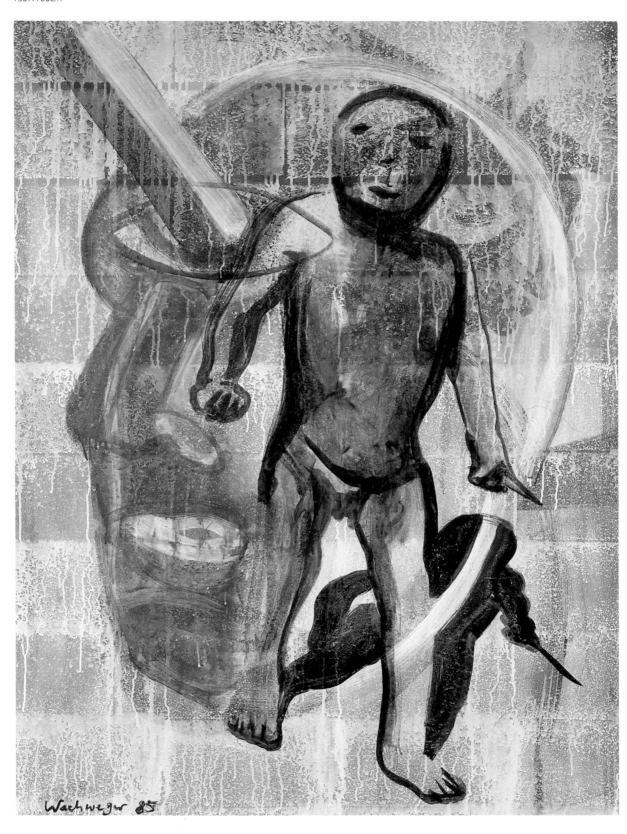

Wachweger 85

1943
Born in Breslau
1963-70
Studied at the Academy for Fine Arts, Hamburg
Lives and works in Berlin since 1978

Solo Exhibitions (selection)
1983
Galerie Schneider, Konstanz
Galleria d'Arte, Silvio R. Baviera, Cavigliano
zuoberst – zuunterst, NGBK, Berlin
1984
Galerie Springer, Berlin
Galerie Springer, Berlin: Art Cologne, Cologne
1985
Die Kunst der Triebe, Museum am Ostwall,
Dortmund and Ulmer Museum (with Ina
Barfuss)
Monika Sprüth, Cologne
Produzentengalerie, Hamburg: RAI 85,
Amsterdam
Galerie Springer, Berlin
1986
Haus am Waldsee, Berlin (with Ina Barfuss)
Silvio Baviera, Zurich
Produzentengalerie, Hamburg

Group Exhibitions (selection) **55**
1980
Galerie Paul Maenz, Cologne
1981
Rundschau Deutschland, Munich and Cologne
Gegen-Bilder, Badischer Kunstverein, Karlsruhe
Galerie Petersen, Berlin
1982
Über 7 Brücken musst Du gehen, Kutscherhaus,
Berlin
La Giovane Transavanguardia Tedesca, Galleria
Nazionale d'Arte Modern, San Marino
1983
Galerie Six Friedrich, Munich
Ansatzpunkte kritischer Kunst, Bonner
Kunstverein, Bonn
Galerie Schneider, Konstanz
Fotocollagen, NGBK, Berlin
1984
Wer überlebt, winkt, NGBK, Berlin
Zwischenbilanz, Joanneum, Graz; Villa Stuck,
Munich; Rheinisches Landesmuseum, Bonn
Tiefe Blicke, Hessisches Landesmuseum,
Darmstadt
von hier aus – 2 Monate Neue Deutsche Kunst,
Düsseldorf
Neue Malerei Berlin, Kestner Gesellschaft,
Hanover
**Die Wiedergefundene Metropole (La
Metropole Retrouvée),** Palais de Beaux Arts,
Brussels and Leverkusen
1985
**1945-1985, Kunst in der Bundesrepublik
Deutschland,** Nationalgalerie Berlin
1986
New German Art, Museum of Portland,
Oregon
Drawings, 12 artists from Berlin, Goethe
Institute, Cairo, Tel Aviv, Cairo, Athens,
Sarajevo
Macht und Ohnmacht der Beziehungen,
Museum am Ostwall, Dortmund
Global Dialog, Primitive and Modern Art,
Louisiana Museum of Modern Art, Humlebaek
Berlin Aujourd'hui, Musée de Toulon
1987
Wechselströme, Bonner Kunstverein, Bonn
Momentaufnahme, Kunsthalle Berlin
Berlinart 1961 – 1987, Museum of Modern Art,
New York

Olaf Metzel	Gerd Rohling	Ina Barfuss	Thomas Wachweger

56

Olaf Metzel

Türkenwohnung – Abstand 12,000DM VB, 1982
(Turk's Flat – Deposit 12,000DM negotiable)

Fünfjahrplan 1985
(Five-year Plan)
Concrete and iron
290×340×15cm

Video

13.4.1981 (April 1987)
Installation

Not in exhibition

13.4.1981 (February 1987)
Installation for the Sculpture-Boulevard (Kurfürstendamm), Berlin

Eichenlaubstudie 1986
(Study of Oak Leaves)

Tankstelle Landsberger Str. 193 (B 2) 1982
(Petrol-station Landsberger Str. 193 (B 2)

Gerd Rohling

Der Dritte Mann 1986
(The Third Man)
Wood, felt, paint, iron
90×650×10cm

Tribute to Joseph Conrad 1986
Wood, paint
30×220×20cm

Bologna 1983/87
PVC plastic

Die Avant-Garde 1985/86
(The Avant-Garde)
Iron, wood
108×110×31cm
Galerie Fahnemann, Berlin

Die Avant-Garde 1986
(The Avant-Garde)
Iron, wood
102×151×32cm
Galerie Fahnemann, Berlin

Die Avant-Garde 1986
(The Avant-Garde)
Iron, wood
194×32×32cm
Galerie Fahnemann, Berlin

Die Avant-Garde 1986
(The Avant-Garde)
Iron, PVC
108×45×43cm

Die Avant-Garde 1987
(The Avant-Garde)
Iron, PVC, rubber
114×52×54cm

Not in exhibition

Roma 1985
PVC plastic
Private collection

Ina Barfuss

Heilige Ignoranz 1983
(Holy Ignorance)
Resin on canvas
195×155cm
Private collection, Berlin

Einblick 1984
(Insight)
Gouache on paper
130×100cm
Galerie Munro, Berlin

Restdeutschland 1984
(Rest of Germany)
Gouache on paper
130×100cm
Lello Papagna, Hamburg

Deutsche Musik I, II 1984
(German Music I, II)
Resin on canvas
200×155cm
Collection Museum Baviera, Zurich

Körpersprache I, II, III 1984
(Body-Language I, II, III)
Dispersion on canvas
225×125cm each
Berlinische Galerie, Berlin

8 Drawings
Ohne Titel 1985/86
(Untitled)
Gouache on paper
29,5×21cm each
Galerie Springer, Berlin

Ina Barfuss and
Thomas Wachweger

6 Joint Drawings
Ohne Titel 1985/86
(Untitled)
Gouache on paper
30×21.5cm each
Galerie Springer, Berlin

Thomas Wachweger

Die Partei hat immer recht ('nen schönen Abend noch) 1983
(The Party is always right – and good evening to you)
Mixed media on paper on canvas
150×184cm
Private Collection

Das Tier in Dir 1984
(The Animal Inside You)
Ink on paper on canvas 217×160cm
Galerie Springer, Berlin

Mater Dolorosa 1984
Mixed media on canvas 195×175cm
Bazon Brock, Wuppertal

Aufstieg II 1984
(Ascent II)
Oil on canvas 130×100cm
Galerie Springer, Berlin

Deutschlehrer Erdmann Erklärt die Welt 1984
(German Teacher Erdman Explains the World)
Mixed media on canvas 160×230
Berlinische Galerie, Berlin

Blendung 1985
(Blinding)
Acrylic on canvas 130×100cm
Monika Sprüth Galerie, Cologne

Zeitreise (Ezra Pound) 1986
(Journey through Time (Ezra Pound))
Inks on canvas 205×220cm
Berlinische Galerie, Berlin

Photoworks 1984

Die Entwicklung des Stammhirns (1) 1976
Die Entwicklung des Stammhirns (2) 1976
(The development of the brain stem)
Wer bin ich? (2) 1970/71
(Who am I?)
Banane – Zitrone 1975
(Banana – Lemon)
Monika Sprüth Galerie, Cologne